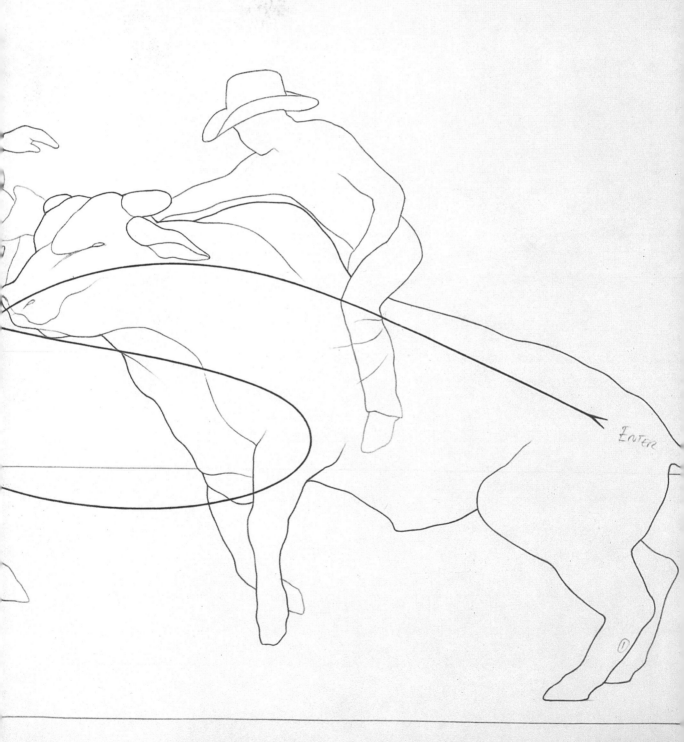

Enter

JENNIFER PASTOR: THE PERFECT RIDE

WHITNEY

This catalogue was published in conjunction with the exhibition
Jennifer Pastor: The Perfect Ride at the Whitney Museum
of American Art, New York, October 6, 2004–January 2, 2005.
The exhibition was curated by Debra Singer, associate curator
of contemporary art, with the assistance of Apsara DiQuinzio,
curatorial assistant, Whitney Museum of American Art.

© 2004 Whitney Museum of American Art
945 Madison Avenue at 75th Street
New York, NY 10021
www.whitney.org

Library of Congress Cataloging-in-Publication Data

Singer, Debra.
 The perfect ride : Jennifer Pastor / Debra Singer, Jan Tumlir.
 p. cm.
 Catalog published in conjunction with an exhibition at the Whitney
Museum of American Art, New York, Oct. 6, 2004 – Jan. 2, 2005.
 Includes bibliographical references.
 ISBN 0-87427-143-6 (hard cover : alk. paper)
 1. Pastor, Jennifer, 1966---Exhibitions. 2. Installations (Art)--
New York (State)--New York--Exhibitions. I. Tumlir, Jan. II. Whitney
Museum of American Art. III. Title.
 N6537.P267A4 2004
 709'.2--dc22

 2004021044

Distributed by

Harry N. Abrams, Inc.
100 Fifth Avenue
New York, NY 10011
www.abramsbooks.com

Abrams is a subsidiary of

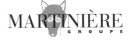

Cover: Adapted from the cover of *Speedwriting, ABC's
Shorthand: College Edition, Book II*, 1966 edition, published by
Speedwriting Publishing Company, Inc., New York, and
Crowell Collier MacMillan Publishing

Speedwriting ®; courtesy Speedwriting Limited; Distance Learning
Foundation, Brighton, England

Endpapers: Flow chart for *The Perfect Ride (animation)*, 2003.
Graphite on paper, 13 ¹/₂ x 17 in. (34.3 x 43.2 cm). Collection of
Dean Valentine and Amy Adelson

JENNIFER PASTOR: THE PERFECT RIDE

Jan Tumlir, with an Introduction by Debra Singer

Whitney Museum of American Art, New York
Distributed by Harry N. Abrams, Inc., New York

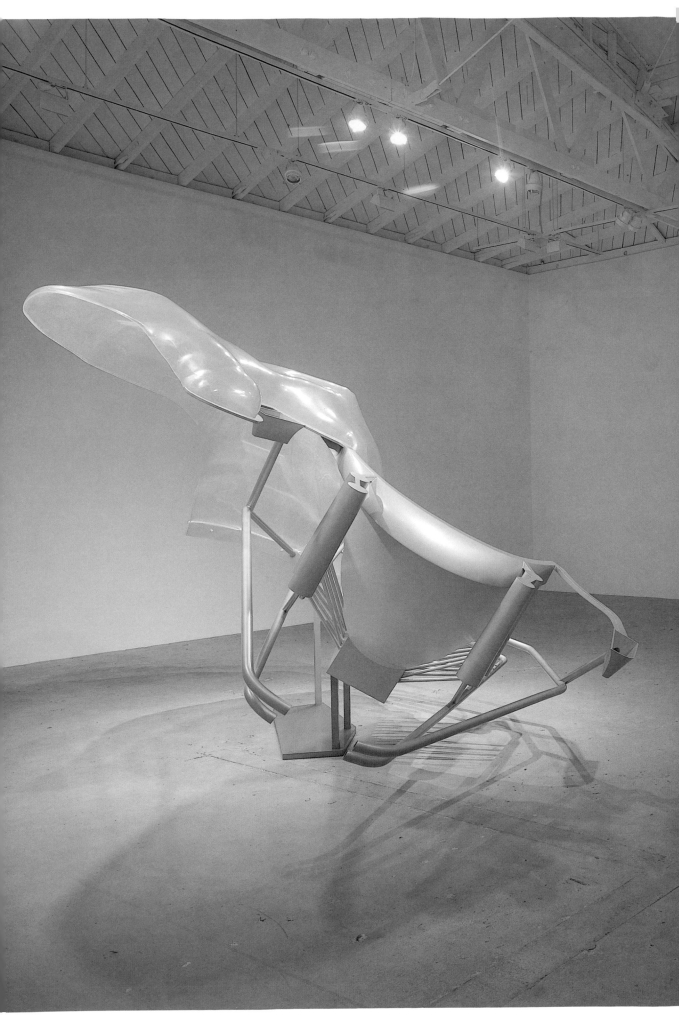

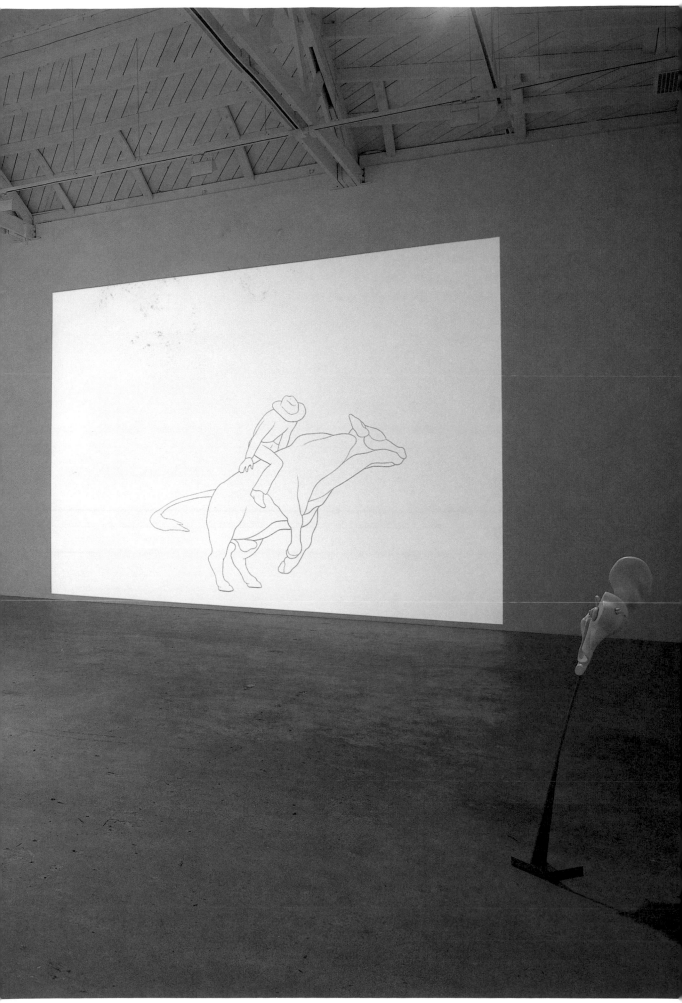

INTRODUCTION

Reflecting the meticulous craftsmanship and intriguing elegance particular to Jennifer Pastor's work, *The Perfect Ride* (2003) triggers a rich web of associations relating to the physical world even as it seems to emerge from the often unsettling, surreal realm of dreams. The installation comprises three intricate reinterpretations of curiously unexpected subjects—a pseudoscientific enlarged rendering of the human inner and outer ear based on the artist's memory of a model in a medical museum; a sleek, fantastical sculpture inspired by the architecture of the Hoover Dam; and a projected line-animation depicting an ideal, yet physically impossible, rodeo ride on a bucking bull. Linking these seemingly disconnected elements is an idea of formal structures and principles that direct systems of movement, suggesting notions of circulation, equilibrium, and balance. Together, the sculptures allude to various forms of humanity's triumphs over nature—scientific, athletic, or cerebral—as well as to the awe inspired by such feats.

As exemplified by *The Perfect Ride*, Pastor draws equal inspiration from art historical precursors, such as Claes Oldenburg and Eva Hesse, and mass-culture phenomena as varied as tourist spectacles, sporting events, and handcraft trade shows. Consequently, her visually sumptuous works often reflect a sensibility that resides somewhere between kitsch and Pop art, but importantly without the irony common to much other work stemming from similar impulses.

Perhaps this unfashionable sincerity of Pastor's art partly springs from the intense commitment she pours into each project. Prior to embarking on a new endeavor, the artist obsessively researches possible subjects, often over a period of years, all the while making innumerable drawings. It is as if she permits herself to probe and stretch the boundaries of reality only after she's mastered every pertinent detail of information. As she designs and fabricates each piece, Pastor ends up investigating the medium of sculpture itself as much as her apparent subjects at hand—as Jan Tumlir so articulately explores in his essay.

Ultimately, through her formal shifts of scale, stylized verisimilitude, and exacting execution, her works seem to oscillate between whimsical abstraction and enhanced realism: what was once potentially familiar morphs into something startlingly alien, evoking an improbable sense of enchantment within the space of the gallery.

This exhibition of *The Perfect Ride* at the Whitney Museum of American Art would not have been possible without the steadfast efforts of many people at the Museum, including Apsara DiQuinzio, curatorial assistant; Tara Eckert, associate registrar; Thea Hetzner, associate editor; Jennifer MacNair, associate editor; Suzanne Quigley, head registrar; Lawrence Rinder, former curator of contemporary art; Joshua Rosenblatt, head preparator; and Rachel de W. Wixom, head of publications. We would also like to acknowledge Lisa Overduin and Shaun Caley Regen of Regen Projects, Los Angeles, and Barbara Gladstone of Barbara Gladstone Gallery, New York, for their ongoing support during every phase of this project. The design of this publication is due to the creative talents of Alice Chung and Karen Hsu, Omnivore, Inc., and was developed in close collaboration with the artist. Finally, it is with great admiration that we thank Jan Tumlir for his wonderfully insightful essay, and most importantly Jennifer Pastor.

Debra Singer
Associate Curator of Contemporary Art

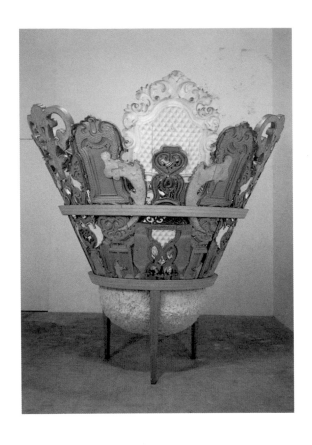

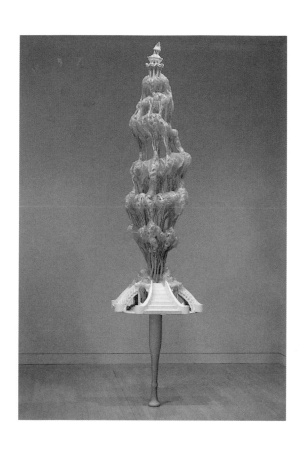

Previous spread, left:
Ta-Dah, 1991. Plastic headboards, bedding material, and
wood, 90 x 94 in. (228.6 x 238.8 cm). Fondazione
Sandretto Re Rebaudengo, Torino, Italy

Previous spread, right:
Bridal Cave, 1993. Plastic medley, 152 x 41 x 41 in. (386.1 x
104.1 x 104.1 cm). Collection of Eileen and Michael Cohen

Opposite:
Christmas Flood, 1994. Mixed media, 6½ x 14½ x 13½ in.
(16.5 x 36.8 x 34.3 cm). Collection of Eileen and
Michael Cohen

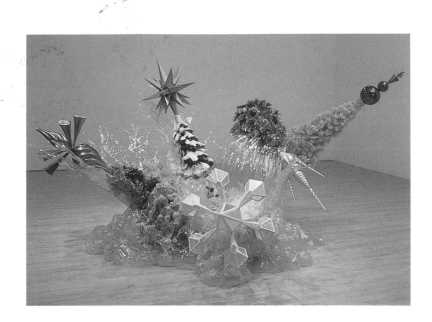

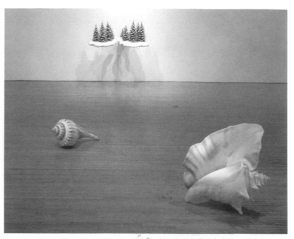
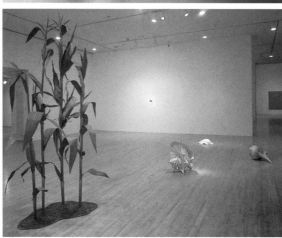

Four Seasons, 1994-96 (installation views at the Museum of Contemporary Art, Los Angeles, 1996). Collection of Eileen Harris Norton and Peter Norton

Above:
Four Seasons: Spring. Plastic, nickel, brass, aluminum oxide, and paint, 3⁵/₈ x 6³/₄ x 1¹/₄ in. (9.2 x 17.1 x 3.2 cm)

Previous page, clockwise from bottom left:
Foreground: *Four Seasons: Fall.* Copper, plastic, polyurethane paint, and oil, 120 x 78 x 57 in. (304.8 x 198.1 x 144.8 cm)
Background: *Four Seasons: Summer.* Fiberglass and paint, three parts, 24 x 21 x 6 in. (61 x 53.3 x 15.2 cm); 19 x 19 x 32 in. (48.3 x 48.3 x 81.3 cm); 33 x 29 x 24 in. (83.8 x 73.4 x 61 cm)

Four Seasons: Spring

Foreground: *Four Seasons: Summer* (detail)
Background: *Four Seasons: Winter.* Wood, pipe cleaners, turf, polyurethane foam, cotton, and flocking, 28 x 78 x 59 in. (71.1 x 198.1 x 149.9 cm)

Four Seasons: Fall (detail)

FANTASTIC FORMALISM: ON AND ABOUT *THE PERFECT RIDE*

Jan Tumlir

1. To suggest that Jennifer Pastor's practice has something to do with a modernist legacy, and more generally with history, is perhaps obvious; much the same could be said for just about any ambitious art being produced right now.[1] To foreground this historicity, however, is to insist on something more crucial and embedded in the work. That is, inasmuch as Pastor has sought, from one exhibition to the next, to provide an objective reply to that perennial question, "What is sculpture?," she has consistently done so by way of comparison to what it is not—namely, painting. Further, if we identify her sculptural foil more specifically as flatness, then it is precisely that historical kind of flatness that becomes pregnant with sculptural potential.

If, as she takes her place on the contemporary stage, Pastor's work resumes a dialogue with a prior moment, then it is entirely with the benefit of postmodern hindsight. The regime of modernist "purification" is followed by a pluralism that reverses the modern "law" just as adamantly as modernism refuted the aesthetic orders that both preceded and produced it. Pastor's early work follows this turn to an extent, as it appears to take shape in direct, calculated defiance of the same "taste for the immediate, the concrete, the irreducible" that modern sculpture once catered to.[2] Hers, accordingly, would favor a taste for the "anything but"—that is, anything but purity, and thereby anything but taste itself.

This ambition, no doubt, underlies a piece like *Ta-Dah* (1991): to make it as baroque, as gaudy, as kitsch as possible. Moreover, its flaunted excess comprises just the sorts of "tactile associations" that critic and art historian Clement Greenberg relates to the monolithic nature of premodern sculpture. These "partake of illusion," he suggests, as well as "the hampering conventions that cling to it."[3] In effect, the monolithic itself is proposed as a dismal objective equivalent to pictorial representation—"the illusion of organic substance or texture in sculpture being analogous to the illusion of the third dimension in pictorial art"—and it is within this context of strict interdiction that it is here, instead, embraced.[4] These same illusory organic textures return to—or better, erupt on—the surface of Pastor's sculpture with all the virulent force and hallucinatory profusion of the repressed.

Ta-Dah is largely made from found parts that all point simultaneously to the idea of a bed, the reality of a bed, and the representation of a bed. A series of hysterically overwrought headboards form a tight circle around a central clump of what looks like bedding material, a segment of which is exposed below. The vague but unshakeable impression that this object somehow has its "ass hanging out" becomes conflated with a suggestion of hidden-ness and deception above. The headboards close about their interior contents like the petals of a monstrous flower. A bed for a head, a dream-machine, Pastor's sculpture announces itself from the first moment as both a cause and effect of the "sleep of reason."

In the grand Platonic struggle between being and seeming, Pastor tends to side with the latter. Here, she does so by fulfilling an incentive literally "implanted" within the shallowest part of her materials—that is, in their ornamental surface details. A feature of so much mass-produced furniture, this tacked-on false front of organic filigree signifies social aspiration as much as the phantasmagorical anxiety that continues to revolve about the machine-made. *Ta-Dah* touches on these points as though in passing, but ultimately none can adequately account for the sheer aesthetic oddity of those leafy patterns. They are meant to be overlooked "in themselves," but this is just what Pastor cannot do. She studies, scrutinizes, and analyzes these patterns, carrying through their logic from the artifice of appearance to the deep structure of substance. The primeval forest, once reduced to a decorative scheme, a curvilinear image atop a rectangular thing, now seeps in, taking hold at the structural core of the bed and contorting it. *Ta-Dah* announces itself as a solution, a triumphant moment, but for whom, or rather, which side?

2. Pastor's first transgression is the most critical since it involves the very site that "the immediate, the concrete, the irreducible" spring from—namely, medium. She is anything but frank or straightforward in her use of materials; it is their potential for transformation, for taking on the appearance of other materials that she consistently exploits. This propensity does not render the question of medium irrelevant, however. There remains in the place of the vanquished taboo an acute sense of wrongdoing. On returning to the space of advanced art, illusionism is degraded; it becomes an impure, unclean thing, and this is exactly how Pastor treats it. As that which superficially enfolds the "thing in itself"—a skin, a coat, a texture, an image—it is by definition removable. But not here—Pastor's illusionism is like the grimace that "freezes" with the tolling of a church bell or a slap on the back. Once arbitrary, it becomes utterly, devastatingly determined.

Similarly, in the case of the career-making *Christmas Flood* (1994), Pastor essentially gives us an illusion materialized. Five artificial Christmas trees, each dwarfed by an immense crowning ornament, are carried on a churning wave of clear cast-plastic. Here, again, the most fantastic part of the work relates directly to its texture, its tactile associations,

and yet this is also the very seat of its being as sculpture. The "water" that bears the trees aloft is the most insubstantial element on view, but it is also the most active, effectively "composing" these trees in space. Like the organic filigree in *Ta-Dah*, it appears among literal things as an emissary from another dimension, that of flatness, of the image, and it quickly converts its surroundings to its own illusory state. A frozen moment, the sculpture confronts us as a kind of photograph that has been "thickened," an effect augmented in its original installation at Richard Telles's long and narrow gallery, as it closely conforms to the aspect ratio of the photographic frame itself. Stepping into this space, one had the impression of entering a tightly cropped picture, every edge and corner pointed out by a sharp ornament as a danger zone to be negotiated with great care.

The rodeo portion of *The Perfect Ride* (2003) also forces the viewer to experience space as contained and condensed, although here it is taken to the extreme. An animated projection, the work claims the gallery wall as its literal surface and support. From the first moment, then, a condition of ultimate flatness prevails, reiterated and reinforced within the image itself, which foregoes any kind of shading or modeling in favor of a crisp linearity that, in its exacting economy, closely resembles the look of technical cutaways.

In a strictly materialistic sense, there is nothing there, only light impressions bounced off a wall that remains untouched throughout it all. The bull's heaving motions are hallucinatory, the effect of stroboscopic flashing and the persistence of vision—and yet they are still felt acutely by us. The image is scaled up to life-size, as if to compensate for its lack of substance, but scale is not only, or even mainly, what defines this as a sculptural experience. Here, again, sculpture is an outcome of a tautological overdetermination of what it is not. At the extreme of illusionism, a reversal occurs: the liar bound up with the lie becomes a kind of truth, an autonomous entity, a "thing in itself."

3. Breaking with the specifics of modernism's sculptural ideal, Pastor nevertheless conserves its general terms and conditions. Sculpture greatly expands on the possibilities both initiated and exhausted by painting, but it has its own limitations, borne of its most definitive traits: its mass, density, and weight; its literalism, objecthood, and presence; and its very actuality, its being there, a thing among things. Ultimately, sculpture's intrinsic lack of virtuality—that illusion which is lost with its separation from the wall—is also what makes it perpetually prone to slipping into the realm of non-art. This holds equally true for the representational and the abstract, as neither is by definition a sculptural quality, and so it makes perfect sense that Pastor's work, which effectively bridges these categories, should be so intent on bringing the wall back into play.

According to Greenberg, sculpture can only overcome its stubborn materiality by putting "an even higher premium on sheer visibility..."[5] This is precisely what must be carried over from painting. A cartoon projected on the gallery wall and proposed as sculpture is perhaps not exactly what the critic had in mind, but it certainly is one way to "draw in the air."[6]

The bull and its rider exist in a flat, rectangular space that is otherwise as empty and white as its ground. As they bound back and forth, subject to a slight perspectival diminution and enlargement, this space itself appears to recede—but, again, only slightly. Pastor's calculations on this point are exceedingly precise, and it might seem odd to insist on measuring to the inch something so essentially vague, but it is here at the scalpel-edge of her cut that the image suddenly opens to a range of objective associations. As much as *The Perfect Ride* begs to be analyzed in terms of its enormously suggestive content, it is ultimately these abstract formal analogies that unify it.

The frame does not track its contents; it remains locked in place and, despite their vigorous exertions, so do the bull and its rider. Touching first one edge and then another, they remain resolutely uncropped, wholly visible throughout. In this way, the frame determines the ride as a figurative extension of a literal gesture: the course of a line dancing across a page. Whereas Pastor's previous sculptures guided the motions of the viewer, in an ever-more concerted manner, between their irregular exteriors and the framed interior of the gallery, this one effectively "contains" its movement. *The Perfect Ride* is made of movement, in fact, a gestural course that flows from the animated rodeo to its two, identically titled companion works. Together, these pieces beget a range of objective analogies that are so baroque and obtuse in their localized specificity that they risk implosion at every turn, but ultimately it is this movement that ties them all together in a supremely elegant knot.

4. What is a "perfect ride" if not one that fuses together the rider with the ridden as well as the vehicle with the course? From a sculptural perspective, it is all about aligning the inside with the outside, which is just what Pastor does in a way that is simultaneously economical and almost unfathomably laborious.

The animated drawing crisply distills countless hours logged before the television, watching bull-riding competitions. Drawn in by this process, Pastor traveled to Cheyenne, Wyoming, to observe the rodeo circuit more closely, to make her own video recordings and, from there, to begin a series of motion studies. Likewise, in her epic rendition of a dam's circulatory system, the evident intricacy of the final sculpture belies the still greater complexity of its conceptu-

alization and execution, which spanned almost six years. Here, too, the work took shape as a multipart research project, an attempt to understand, as Pastor puts it, "the economy and invention of great engineering structures, like the thin shell constructions of Heinz Isler and Edouardo Torroja and the work of bridge builders like Othmar Ammann, Eugène Freyssinet—and especially Robert Maillart."[7] She organized fact-finding missions to the Hoover Dam and other such modernist monuments to engineering, the sculpture slowly materializing, first as a drawing, then a model, and finally the cast-plastic and aluminum behemoth that was first exhibited at the 2003 Venice Biennale.

Structured around a functional water-circulation system, this "Perfect Ride" comprises a surrounding hillside as well as the river that runs through it. Underlying the delirious convolutions of its outward shape, however, is "a movement that is true," according to Pastor. As with the bull ride and the final element in this sculptural triptych, the ear, she conceives of objective form as a dreamlike extrapolation, sheer texture woven like cotton candy around a motion, a gesture, but one that is technically accurate. All of the pieces are supported on a specific, gestural armature, researched to a point where it becomes irrevocable in each instance. Yet the thread holds: water describes a course through the dam that is akin to the structure of the inner ear, and this in turn is akin to the pathway of the bull and its rider, which seem to move through water themselves.

Whether we define the disparate parts of the piece in categorical terms as sports, engineering, and anatomy; or else in terms of subject matter as person, place, and thing; or even in material terms as three different types of depiction, *The Perfect Ride* comes down to a balancing act, like all sculpture. Pastor gives us three elements that are as seemingly unrelated to each other as to the conventional parameters of modernism. Yet it is here, where one would expect to find only the random and arbitrary—the "non-art"—that her abstract intentionality takes root. Scrupulously quantified by Pastor, difference becomes instead a common denominator.

5. Initially related to the varied referents of *The Perfect Ride*, unlikeliness gains formal emphasis by means of scale, which runs the gamut between the monumental and the miniature. However, the largest object on view, the dam, is in fact reduced, whereas the smallest, the ear, is enlarged. These disorienting shifts announce a break with the logic of the found object; like its predecessor, *Four Seasons* (1994-96), *The Perfect Ride* is a wholly made work and, accordingly, it treats scale as a perfect variable. Scale both exaggerates and downplays the differences between the work's individual parts, but on a more fundamental level, it reduces the totality of it to a condition of even virtuality.

As though to prepare for the coup de grâce, the "snap" that all athletes cherish at the fulcrum between tension and torque, Pastor draws these differences into the same virtual register. Three distinct categories of experience, each culled from a representative site and modeled on an exemplary object, are arranged in a row and sliced open. Exposed in this way, she points up how vast morphological divergences derive from a set of related causes. The choreography of the bull ride mimics the circulatory systems of the dam and ear, and vice versa. Overlaid, the sculpture's individual parts yield a consistent pattern, an abstraction in the truest sense, but also a movement, a gesture, a dancing line.

Within the alternating obstructions and flows of its structural system, *The Perfect Ride* appears to resume the thought process that gave rise to it. Where it "clicks," as Pastor puts it, is precisely the point of highest tension between its given and variable, its informed and improvised, components. The line that runs through the sculpture's entirety is at once traced from nature and freeform, responding only to the dictates of its surface and ground. On the very threshold of image and object, its condition is from the outset one of flickering paradox, but this is a paradox measured out to the inch, and proposed as a sculptural solution—the only one possible and thereby also the best.

NOTES

1 Periodically, Clement Greenberg would stray from his first area of expertise (painting) and venture a pronouncement on the state of sculpture. His most focused papers on this regard are "The New Sculpture" (1949), "Sculpture in Our Time" (1967), and "Recentness of Sculpture" (1967).

2 Clement Greenberg, "Sculpture in Our Time," in *The Collected Essays and Criticism*, Vol. 4, 1957-1969, ed. John O'Brian (Chicago: University of Chicago Press, 1993), 55.

3 Ibid., 59

4 Ibid.

5 Ibid., 60

6 Ibid.

7 Jennifer Pastor, quoted in "A Thousand Words: Jennifer Pastor Talks about 'The Perfect Ride,'" *Artforum* 41 (Summer 2003): 155.

WORKS IN THE EXHIBITION

The Perfect Ride, 2003. Collection of the artist; courtesy Regen Projects, Los Angeles, and Barbara Gladstone Gallery, New York

The Perfect Ride (animation). Line-drawing animation, black-and-white, silent; 3 min.

The Perfect Ride (ear). Polyurethane and steel, 46½ x 26 x 10 in. (118.1 x 66 x 25.4 cm)

The Perfect Ride (dam). Steel, aluminum, and plastic, 102 x 108 x 153 in. (259.1 x 274.3 x 388.6 cm)

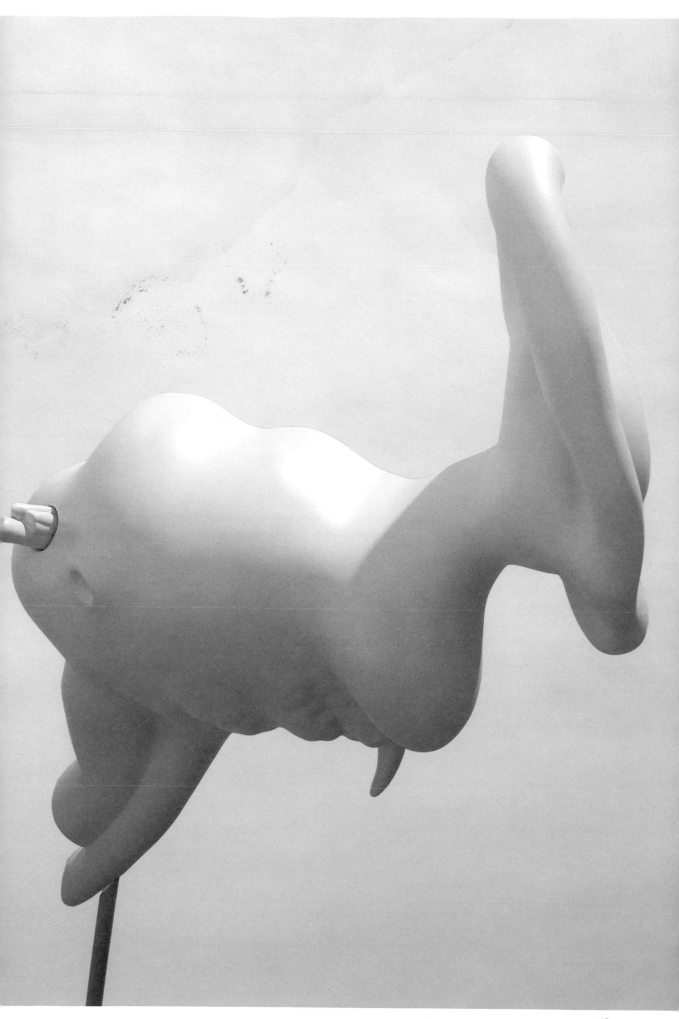

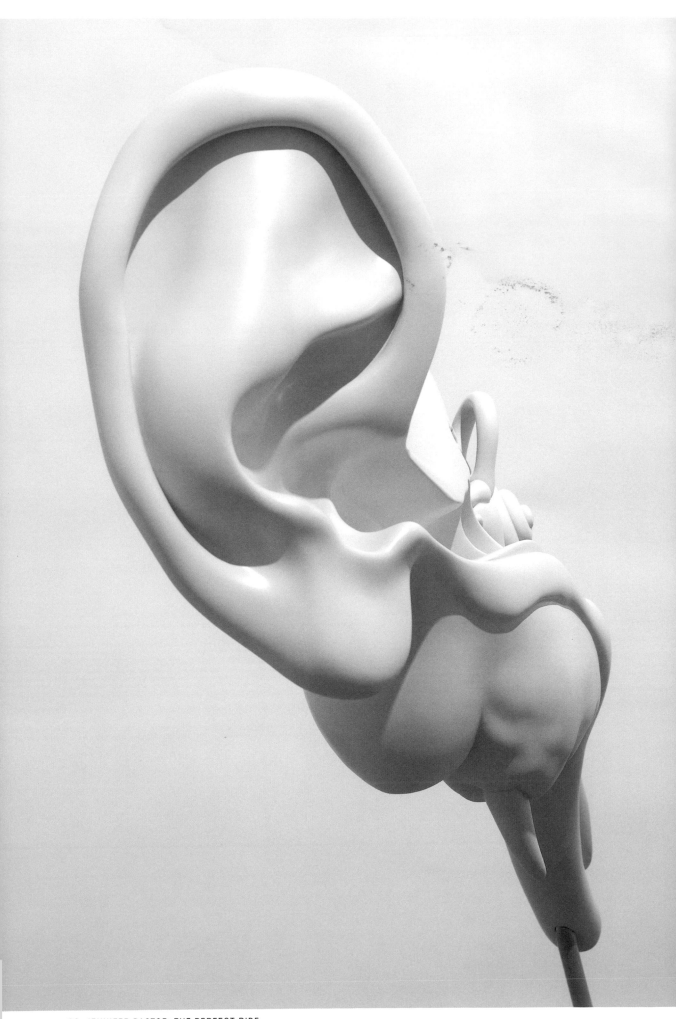

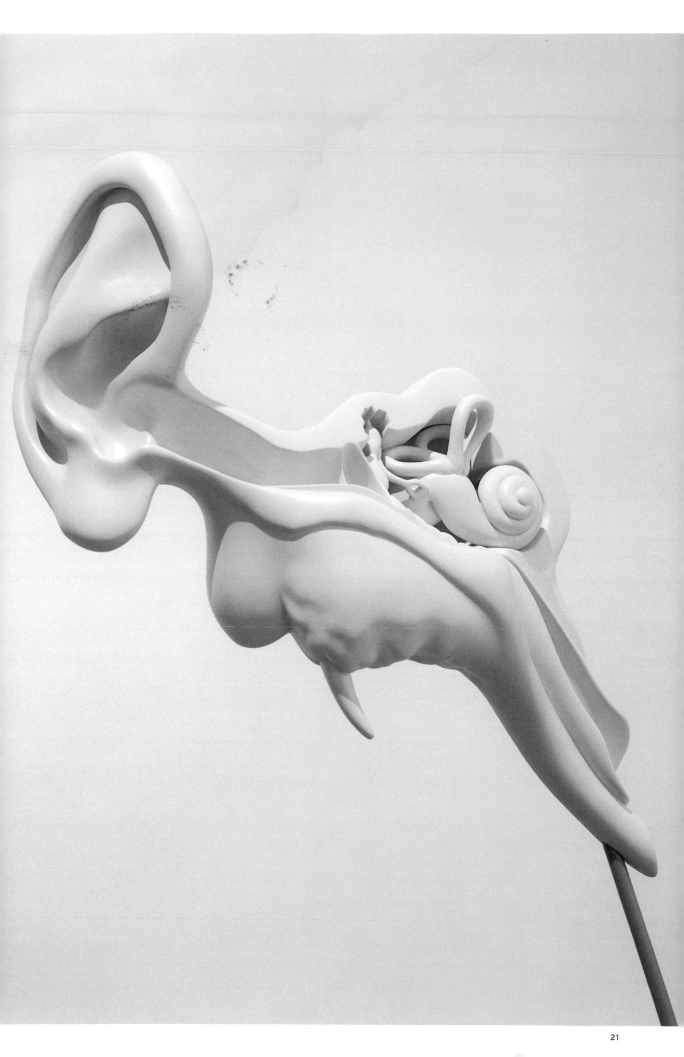

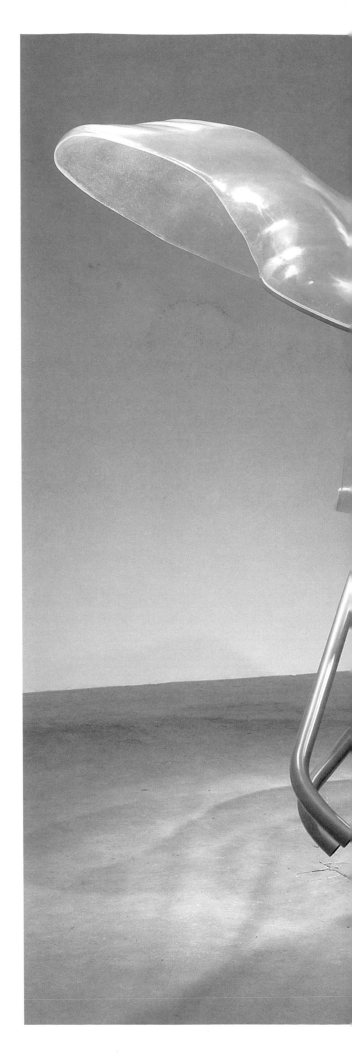

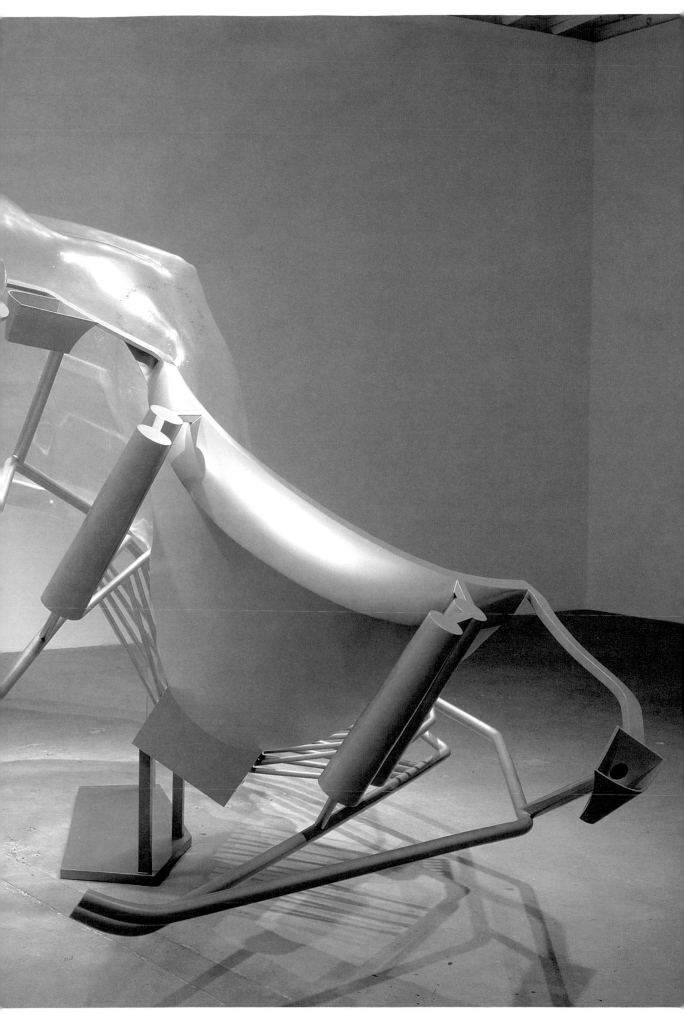

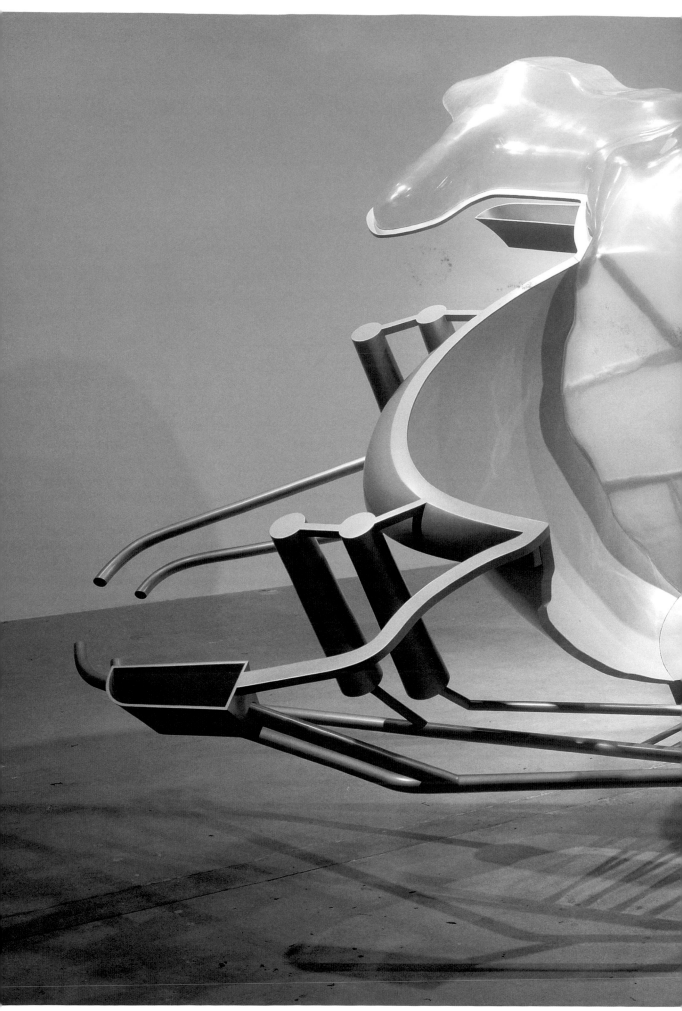

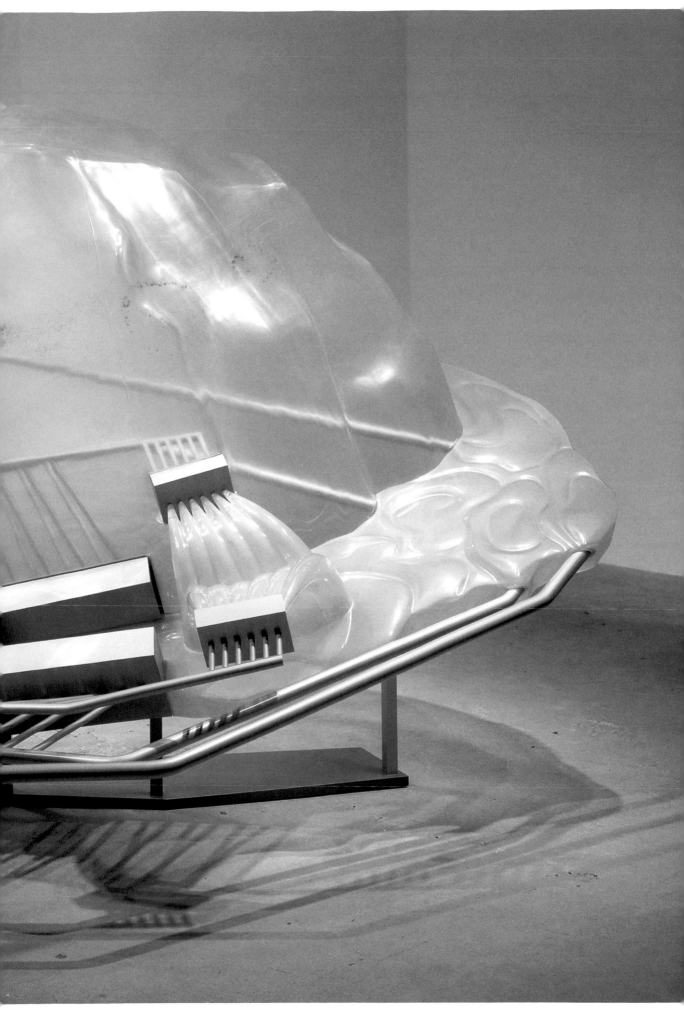

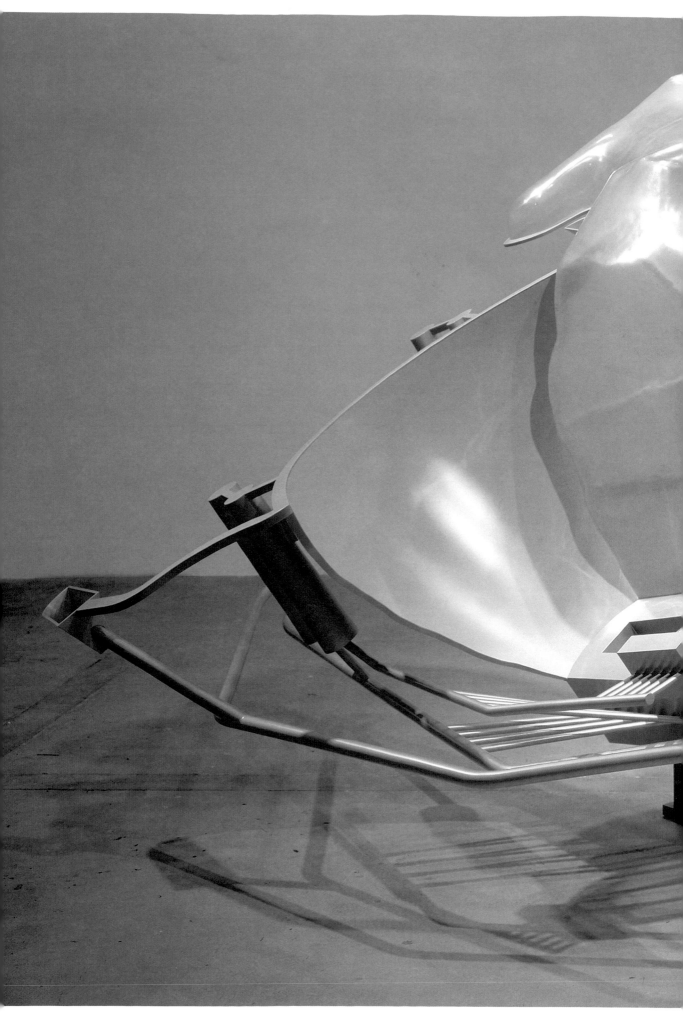

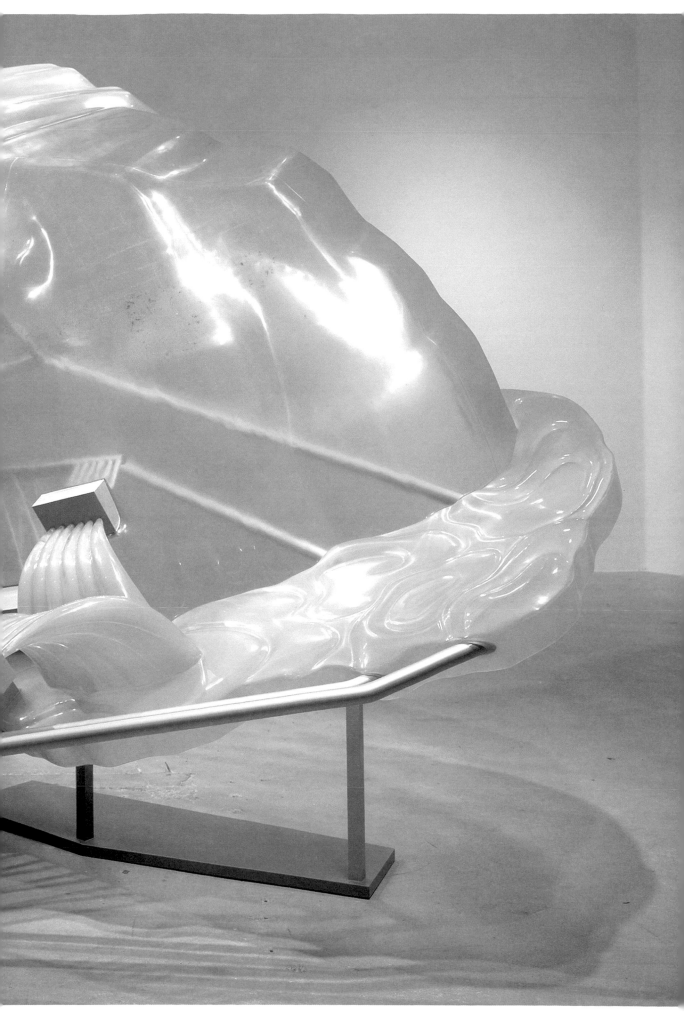

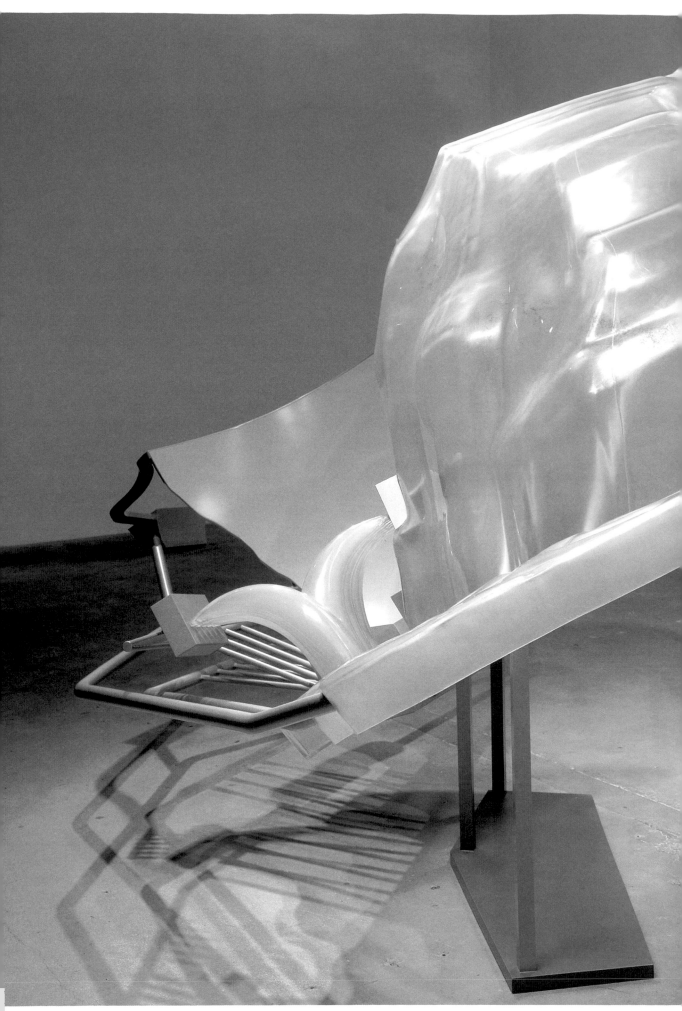

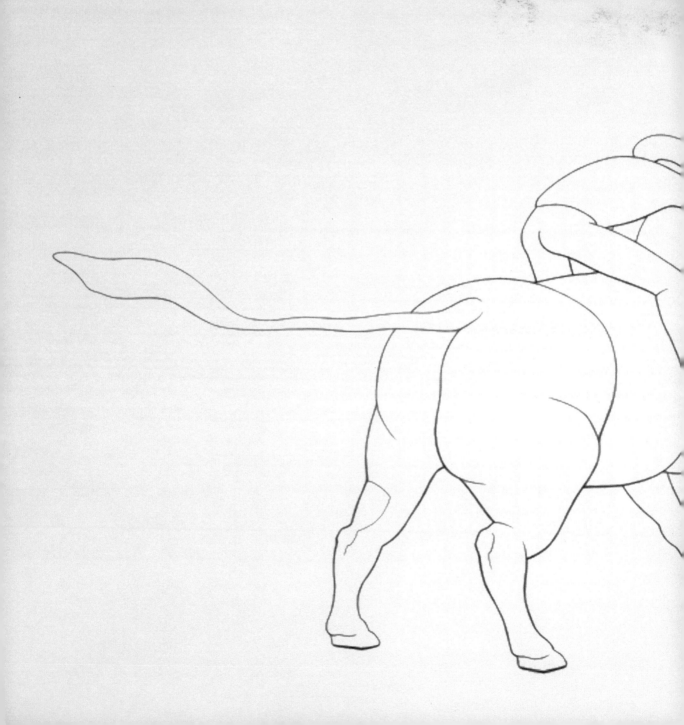

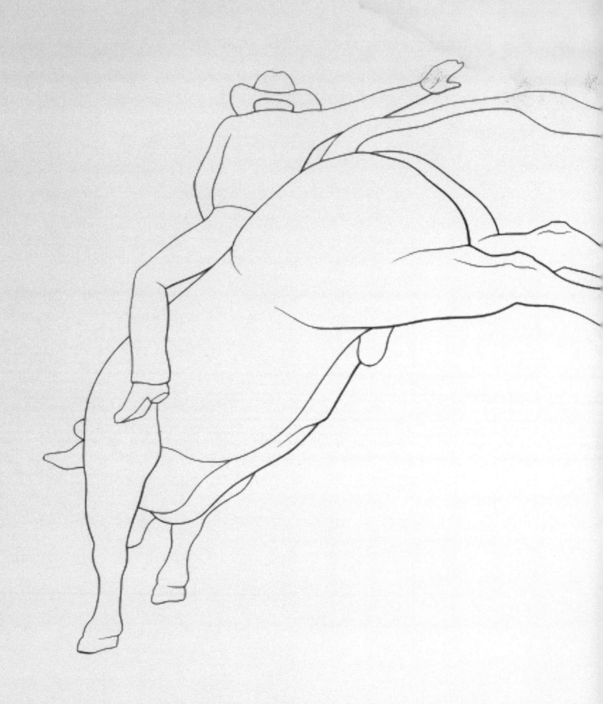

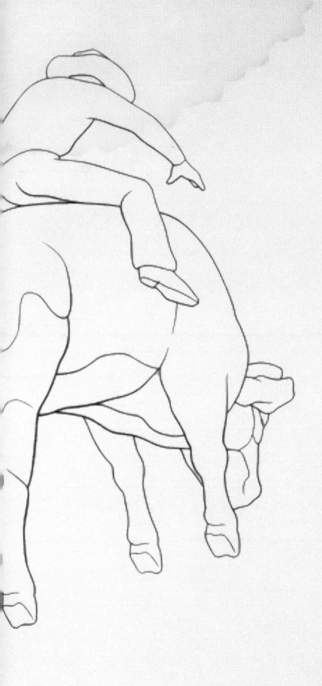

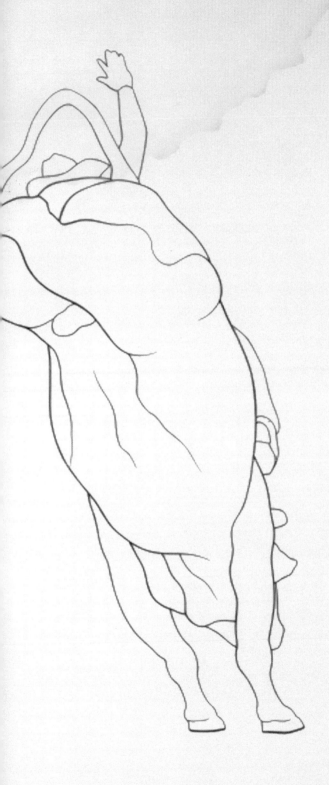

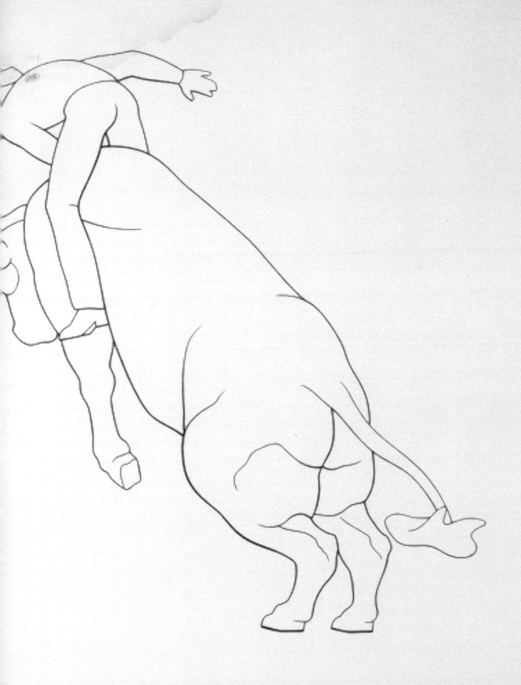

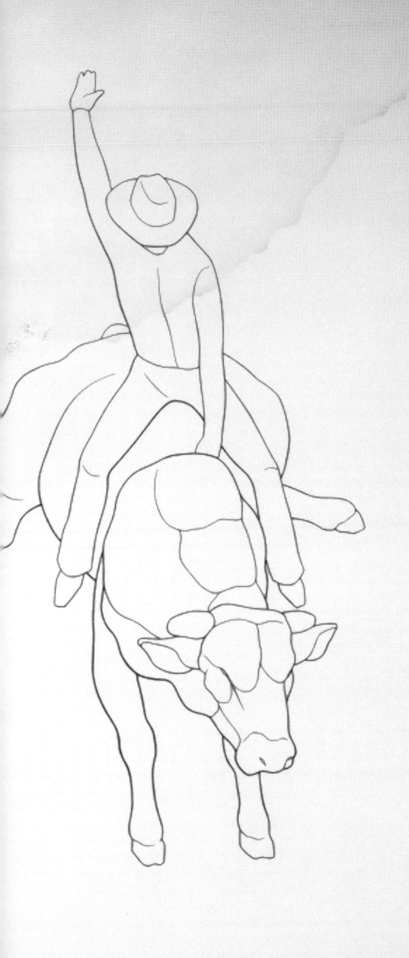

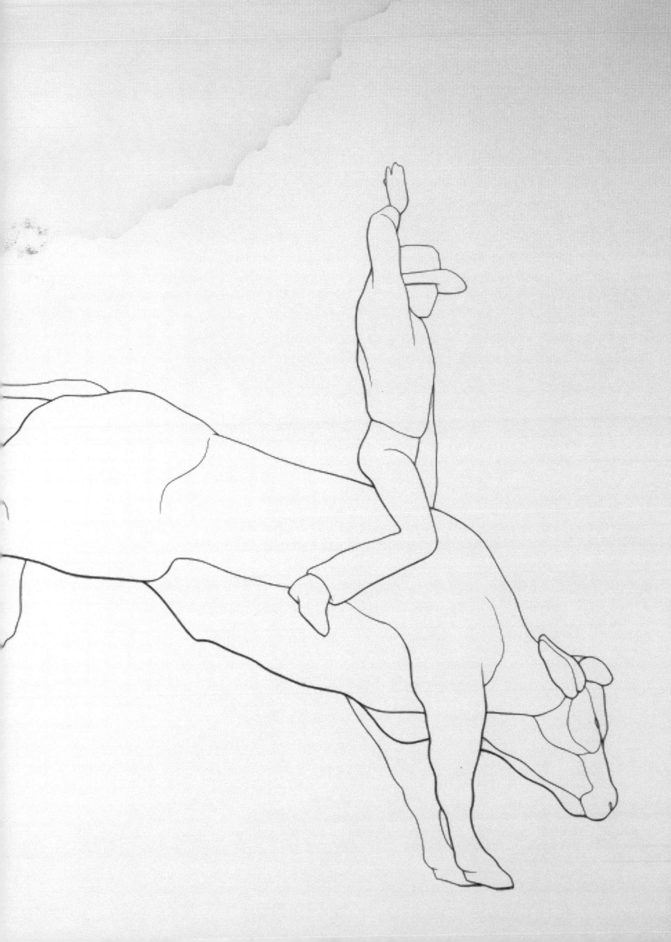

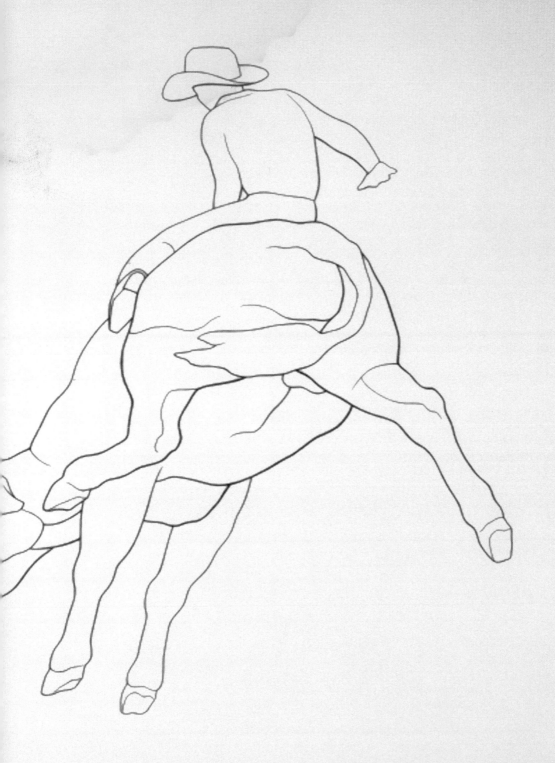

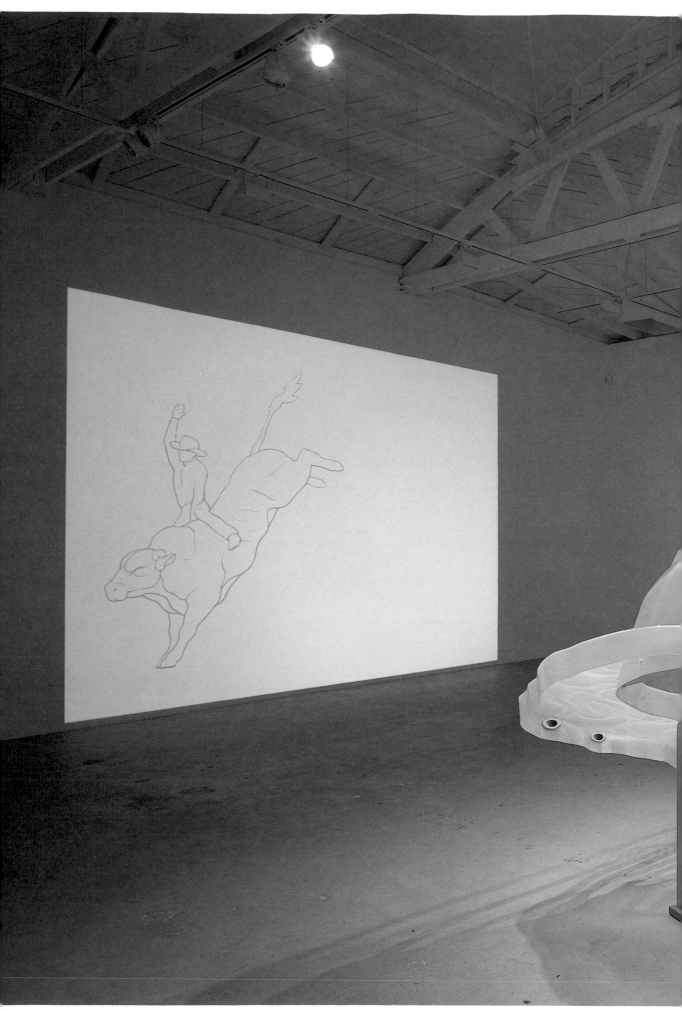

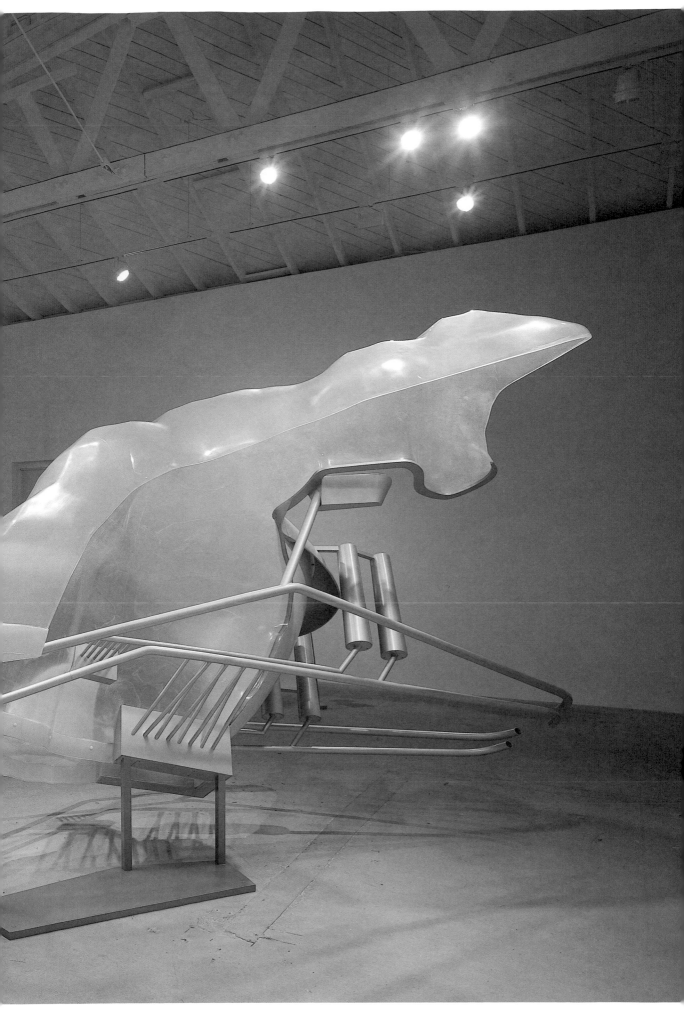

CHRONOLOGY

JENNIFER PASTOR

Born in Hartford, Connecticut, 1966
University of California, Los Angeles (MFA, 1992)
School of Visual Arts, New York (BFA, 1988)
Lives and works in Los Angeles and San Diego

SINGLE-ARTIST EXHIBITIONS

2004-05
Jennifer Pastor: The Perfect Ride, Whitney Museum of American Art, New York

The Perfect Ride, Regen Projects, Los Angeles

1996
Jennifer Pastor, Museum of Contemporary Art, Chicago (traveled to Museum of Contemporary Art, Los Angeles)

1995
Studio Guenzani, Milan

1994
Richard Telles Fine Art, Los Angeles

SELECTED GROUP EXHIBITIONS

2003
La Biennale di Venezia, Dreams and Conflicts: The Dictatorship of the Viewer, 50th International Art Exhibition, Venice

Outlook International Art Exhibition, Athens

2002
Drawing Now: Eight Propositions, The Museum of Modern Art, Queens, New York

2001
Drawings, Regen Projects, Los Angeles

2000
Matthew Barney, Jennifer Pastor, Charles Ray, Barbara Gladstone Gallery, New York

Works on Paper from Los Angeles, Studio Guenzani, Milan

1999
Greengrassi, London

1998
L.A. Times, Palazzo Re Rebaudengo per l'Arte Contemporanea, Guarene d'Alba, Italy

1997
New Work: Drawings Today, San Francisco Museum of Modern Art

1997 Biennial Exhibition, Whitney Museum of American Art, New York

Present Tense: Nine Artists in the Nineties, San Francisco Museum of Modern Art

Sunshine & Noir: Art in L.A. 1960-1997, Louisiana Museum of Modern Art, Humelbaek, Denmark (traveled)

1996
Controfigura, Studio Guenzani, Milan

23 Bienal Internacional de São Paulo: Universalis, São Paulo

1994
Surface de Réparations 2, Fonds Régional d'Art Contemporain de Bourgogne, Dijon, France

1993
Feature Inc., New York

Invitational 93, Regen Projects, Los Angeles

AWARD

1995
The Louis Comfort Tiffany Foundation

ACKNOWLEDGMENTS

The artist wishes to thank Regen Projects, Los Angeles, and Barbara Gladstone Gallery, New York, for their generous support.

Charles Ray for his concern and insights.

Mark Rossi, Helen Vivés, and Perfecto Hernandez for their exceptional fabrication and production assistance.

SELECTED BIBLIOGRAPHY

ARTICLES

Gerstler, Amy. Reviews. *Artforum* 33, November 1994, 93.

Greene, David A. Openings. *Artforum* 35, September 1996, 98-99.

Harvey, Doug. "Jennifer Pastor at MOCA." *Art Issues*, no. 47 (March/April 1997): 46.

Kandel, Susan. "Interview with Jennifer Pastor." *Index*, June 1996, 28-33.

_____. "Jennifer Pastor: Dream-Day Residue." *Art + Text* 55, October 1996, 51-53.

_____. "Jennifer Pastor Takes Classical Command of Space." *Los Angeles Times*, May 9, 1994.

Knight, Christopher. "Prying Perceptions Loose during 'The Perfect Ride.'" *Los Angeles Times*, May 14, 2004.

Myers, Terry R. "Jennifer Pastor." *Blocnotes Art Contemporain*, no. 7 (Fall 1994): 72.

Pastor, Jennifer. "Untitled Drawing, 1979." *Blocnotes Art Contemporain*, no. 8 (Winter 1995): 52-53.

_____. "White Curls, White Bubbles." *Framework* 7, no. 2 (1996): 22-23.

Rugoff, Ralph. "The Garden of Uncanny Delight: Tomatoes from Space, Christmas Ghosts." *LA Weekly*, May 13, 1994.

Tumlir, Jan. "A Thousand Words: Jennifer Pastor Talks about 'The Perfect Ride.'" *Artforum* 41, Summer 2003, 154-55.

Weissman, Benjamin. "Seasonal Change." *Frieze*, no. 31 (November–December 1996): 46-49.

BOOKS/EXHIBITION CATALOGUES

Aguilar, Nelson, and Agnaldo Farias. *Bienal Internacional de São Paulo, 23, 1996: Catalago da exposicao Universalis*. São Paulo: Fundacao de São Paulo, 1996.

Bonami, Francesco, and Daniel Birnbaum, eds. *La Biennale di Venezia, 50th International Art Exhibition, Dreams and Conflicts: The Dictatorship of the Viewer*. Venice: Marsilio Editori, 2003.

Garrels, Gary. *Present Tense: Nine Artists in the Nineties*. San Francisco: San Francisco Museum of Modern Art, 1997.

Hoptman, Laura. *Drawing Now: Eight Propositions*. New York: The Museum of Modern Art, 2002.

Joachimides, Christos M. *Outlook International Art Exhibition*. Athens: Adams Publications, 2003.

Pastor, Jennifer, with essay by Amada Cruz. *Jennifer Pastor*. Chicago: Museum of Contemporary Art, 1996.

Phillips, Lisa, and Louise Neri. *1997 Biennial Exhibition*. New York: Whitney Museum of American Art, 1997.

This publication was produced by the Publications Department of the Whitney Museum of American Art, New York: Rachel de W. Wixom: head of publications; Thea Hetzner: associate editor; Jennifer MacNair: associate editor; Makiko Ushiba: manager, graphic design; Vickie Leung: production manager; Anita Duquette: manager, rights and reproductions; Arianne Gelardin: publications assistant.

Editor: Jennifer MacNair
Proofreader: Thea Hetzner
Catalogue Design: Omnivore, Inc.

Printing and Color Separations: Professional Graphics, Rockford, Illinois

Printed and bound in the U.S.A.

Photographs courtesy Regen Projects, Los Angeles

Los Angeles-based writer and curator Jan Tumlir is on the editorial board of *Xtra*, and contributes regularly to *Artforum*, *Frieze*, and *Flash Art*. His essays have appeared in catalogues for such artists as Bas Jan Ader, Uta Barth, David Bunn, Jessica Bronson, Jeroen de Rijke & Willem de Rooij, Jorge Pardo, and Pae White. Tumlir teaches art and film theory at Art Center College of Design in Pasadena and the University of Southern California. He curated the exhibition *Morbid Curiosity* at ACME in Los Angeles (September 2001), which traveled to the I-20 Gallery in New York (April 2002) and recently yielded a book by the same title.

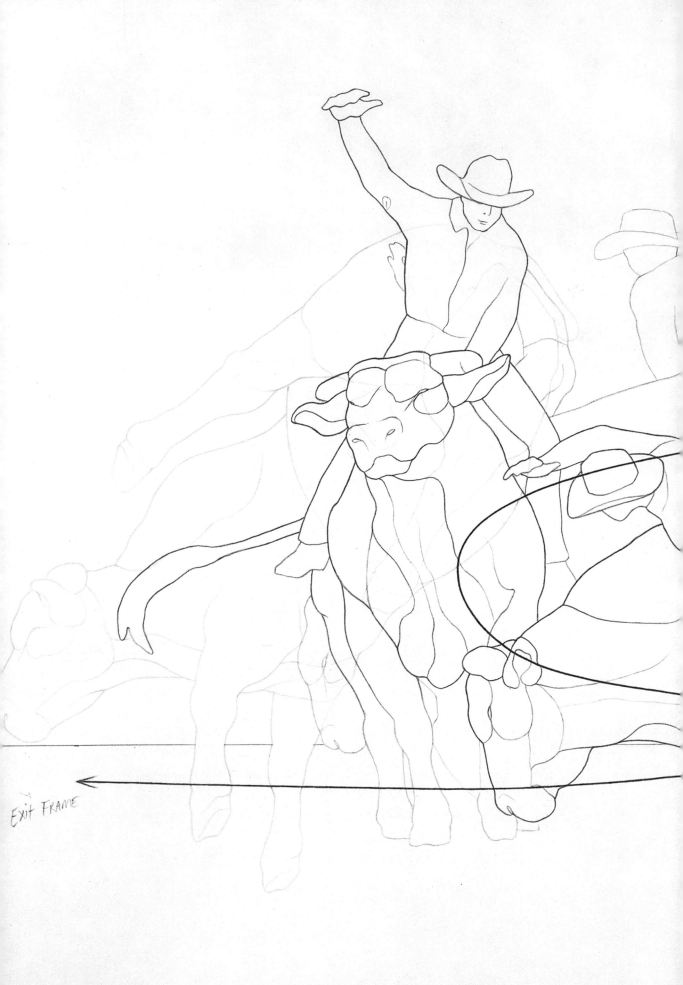

EXIT FRAME